longings

sensual
caress

tender
embrace

swept
away

Contents

Introduction _____ 4

First Sight _____ 8

Swept Away _____ 30

Burning Hearts _____ 52

Overwhelming Desire _____ 74

Everlasting Love _____ 102

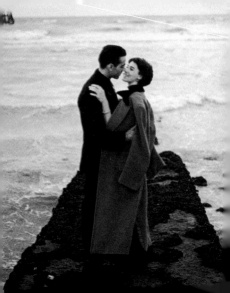

Passion

Visions of Love, in Word and Image

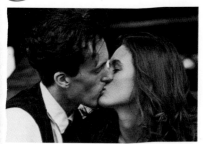

RUNNING PRESS
PHILADELPHIA · LONDON

A Running Press Miniature Edition™

© 1997 by Running Press

Printed in China

Library of Congress Cataloging-in-Publication Number 96-71131

ISBN 0-7624-0151-6

This book may be ordered by mail from the publisher.
Please include $1.00 for postage and handling.
But try your bookstore first!

Running Press Book Publishers
125 South Twenty-second Street
Philadelphia, Pennsylvania 19103-4399

to commit to memory each curve
and blemish, everything that makes
our beloved unique. We belong
to each other. Our hearts beat
hungrily, conscious only of the power
of our passion.

Passion engages all of our senses
and sensibilities. While lasting relation-
ships are built on love and friendship,
it's passion that we strive to capture
and recreate. It is the thrill of the
chase, the excitement of a first kiss,
and the rapture of love—the most
intense sensation in our extensive
emotional repertoire.

Introduction _____

Passion. In some cases it comes upon us suddenly and with overwhelming intensity. In others it builds slowly over a number of years, creeping almost unnoticed into our hearts and souls until it becomes too powerful to ignore. We rarely know what specific traits in another person inspire it. It is not quantifiable. It is beyond words. It defies all rational explanation. And yet, we know it's there.

We are driven by the burning desire we feel as we gaze longingly at our lover, tracing the outline of their face and body as we desperately try

No matter how hard we try, we are unable to sufficiently express the passion we feel for another. We try desperately to put our feelings into words, but each attempt seems simple and weak, a mere shadow of our true feelings. Every experience is enriched by our passion, and our lives are changed forever.

Our passion is a delicious torment—simultaneously wonderful and terrifying. Why do we love so strongly? We may never know, but we would never want it any other way.

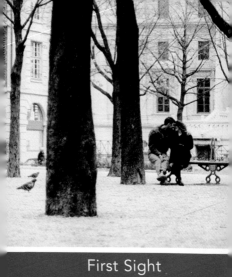

First Sight

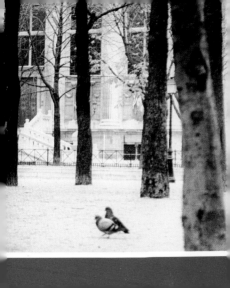

*Never underestimate
the power of passion.*

Eve Sawyer (b. 1922)
American journalist

A thousand emotions have swept
through me tonight. I don't compre-
hend half of them. . . . I wonder
if any night on earth will ever again
be like this one. It is like a night
in a dream.

Kate Chopin (1851–1904)
American writer

Passion _____

I couldn't have imagined, before, how loving him would change everything. Even inanimate things, chairs and tables, ugly city corners, take on a kind of importance. As if they are painted with a layer of fresh light, different colors. Every dull detail takes on a new significance, just because he exists.

Rosie Thomas (b. 1947)
English writer

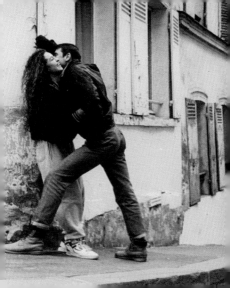

Passion makes every
detail important; there
is no realism like the
insatiable realism of love.

G. K. Chesterton (1874–1936)
English journalist and writer

That *energy of observing* is mar-
velous. When you desire someone
so much, and she's right there
in front of you, there's something
very special about not touching,
and just letting *the light* caress her.

Bert Stern
American photographer

Passion _____

What a heavenly morning!
All the bells are ringing; the sky is so
golden and blue and clear—and
before me lies your letter. I send you
my first kiss, beloved.

Robert Schumann (1810–1856)
German composer

Today a new sun rises for me;
everything lives, everything
is animated, everything seems
to speak to me of my passion,
everything invites me to cherish it . . .

Anne (Ninon) de Lenclos (1620–1765)
French courtesan

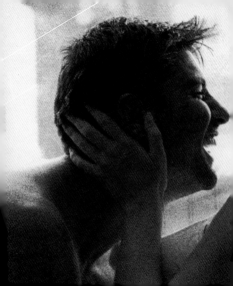

Passion ———

She kept remembering that long-ago
fall day she opened her apartment
door and saw him standing there
for the first time. At that precise
moment—so it seemed now in the
remembering—she had taken her
heart out and given it to him.

Judith Henry Wall (b. 1940)
American writer

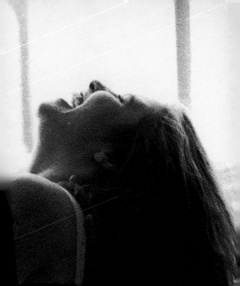

When I meet a girl and I'm really
deeply attracted to her, I go
out of my mind. It's overpowering,
just like someone reaching in
and grabbing hold of my heart . . .

Woody Harrelson (b. 1961)
American actor

It was only their third date but it was like they had never lived without each other.

David Baldacci
American writer

The two . . . were . . . obviously amorous, still overcome by that first thrill of love, the amazing news that in the flight of life, solo thus far, there might be a co-pilot.

Scott Turow (b. 1949)
American writer

Passion _____

Oh, now you are mine!
At last you are mine! Soon—in
a few months, perhaps, my angel
will sleep in my arms, will awaken
in my arms, will live there. All your
thoughts at all moments, all your
looks will be for me; all my thoughts,
all my moments, all my looks, will
be for you! . . .

Victor Hugo (1802–1885)
French writer and poet

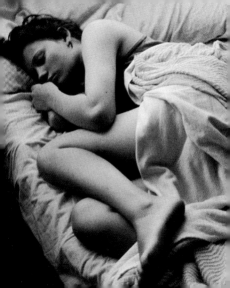

"Tell me, what did you love most about Louis?"

"His face lighting up to see me, it was as if someone had turned on a switch . . ."

Maeve Binchy (b. 1940)
Irish writer

. . . I recall what initially attracted us to each other—the way our ideas grew in logic or hilarity or passion . the more we talked.

Amy Tan (b. 1952)
American writer

I love you with my whole heart
and I want you, and I am full
of happy happy allegiance. I want
our lives to be one roof, one pillow,
one kiss, one life-work-of-song, . . .
one glory, one sadness, one mutual
loving and praying.

Vachel Lindsay (1879–1931)
American poet

Of all the whispers that he yet
had heard, that one was the most
charged, colored with all the shades
of longing. He looked at her kindling
eyes and knew he had never met
anyone else he had wanted so much
to connect with, even though he
didn't know her at all. He leaned
down just as she tilted her face up,
and they kissed.

Nina Kiriki Hoffman
American writer

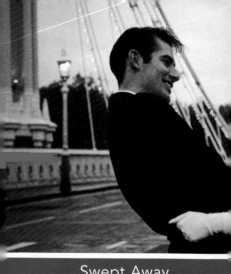

Swept Away

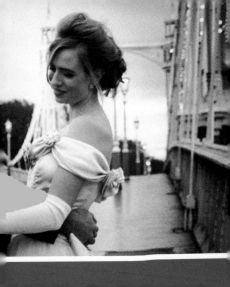

Passion will not be commanded. It commands us ∴ ∙

Jeanette Winterson (b. 1959)
English writer

Love is not a decision your brain
makes. It's a feeling you know
somewhere else, and your brain
catches up. But love challenges
you in areas you need to be chal-
lenged in. It rests somewhere in not
knowing what's going to happen.
Not predicting. That's what I love.

Meg Ryan (b. 1962)
American actress

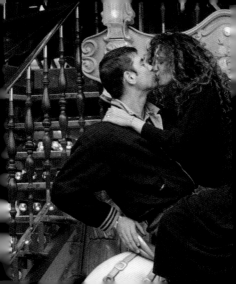

Oh love! . . . Who's to say what it is?
It's like the verb for *hope* and *wait*.
It has no single meaning.

Harriet Doerr (b. 1910)
American writer

When one does not love too much one does not love enough.

Blaise Pascal (1623–**1** 662)
French scientist and phi**l**osopher

Where love is concerned,
too much
is not even enough.

Pierre-Augustin Caron de Beaumarchais
(1732–1799)
French playwright

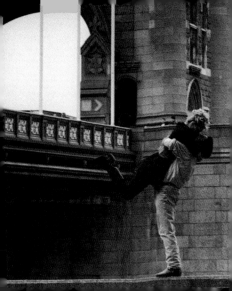

Love is like a fever;
it comes and goes without
the will having any
part in the process.

Stendahl (1782—1842)
French writer

*Our passions play
the tyrant in our breasts.*

Persius [Aulis Persius Flaccus] (34–62)
Roman writer

. . . and here she was, her arms warm around him, her mind snuggled beside his, her scent wild and enticing and familiar. The last guardian of his heart put down its shield. _ . .

Nina Kiriki Hoffman
American writer

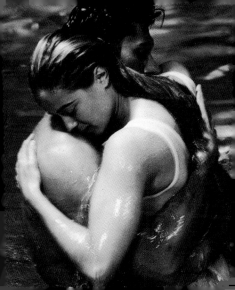

Love is not thinking
about it; it is doing it.
It is loving.

Eric Butterworth
American minister

. . . being in love brings out both
the best and the worst in us. One
day we're generous and sensitive
to a fault, and the next we're not fit
to shoot. Our lives become lessons
in extremes.

Patricia D. Cornwell (b. 1956)
American writer

Passion———

. . . love?
It's just a word.
Why does it
have such power?

Susan Trott (b. 1937)
American writer

When you feel love,

you expose more.

Laura Dern (b. 1966)
American actress

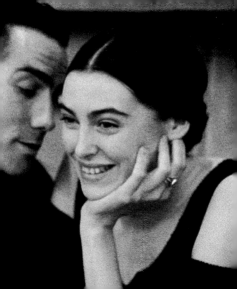

O, God! for two days, I have been
asking myself every moment
if such happiness is not a dream.
It seems to me that what I feel
is not of earth. I can not yet
comprehend this cloudless heaven.

Victor Hugo (1802–1885)
French writer and poet

Passion never reasons.

Comtesse Du Barry (1746–1793)
French countess

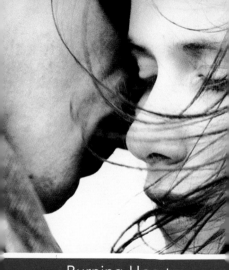

Burning Hearts

Passion ———

Passion . . . is
volatile, molten,
ever ready
to erupt and spill.

Michael Dorris (b. 1945)
and Louise Erdrich (b. 1954)
American writers

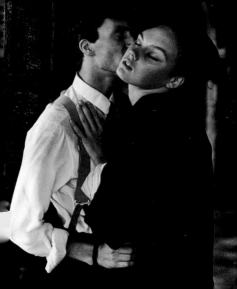

Passion

All the danger, all the tension
had been converted into this mute
longing. I could feel the lick of it
along my legs, seeping through
my clothes. . . . The heat seemed
to arc through the space between
us like a primitive experiment,
born of night. . . . I knew that what
I saw in him was a strange reflection
of myself.

Sue Grafton (b. 1940)
American writer

Thou art to me
a delicious torment.

Ralph Waldo Emerson (1803–1882)
American writer

*Having felt it with her
own body, she knew
a look could start a fire.*

**Laura Esquivel (b. 1950)
Mexican writer**

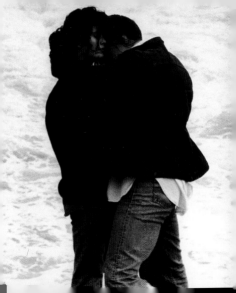

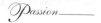

. . . a lover is defined as
someone you yearn for.

Erica Jong (b. 1942)
American writer and poet

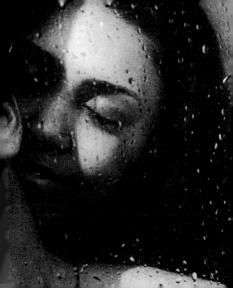

Passion _____

Our bodies burned when we were together. I do not have any other way of saying it. I think it happens but once and only to the very young when it feels like your skin could ignite at the mere touch of another person. . . . You get to love like that but once.

Pat Conroy (b. 1945)
American writer

Love

is trembling happiness.

Kahlil Gibran (1883–1931)
Lebanese writer and poet

My heart overflows with emotion and joy!. . . All this can only be, is surely nothing less than a gentle ray streaming from your fiery soul, or else some secret poignant teardrop which you have long since left in my breast.

Franz Liszt (1811–1886)
Hungarian pianist and composer

I didn't understand. . . .
I didn't understand
about love before now.
Oh, it's such torture.
Such joy!

Rachel Billington (b. 1942)
English writer

*I wanted to kiss this
woman so bad,
I wondered how I
could stay alive without it.*

Richard Cohen (b. 1952)
American writer

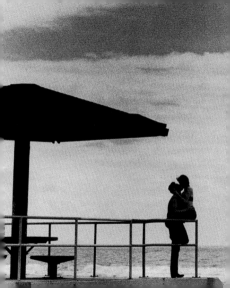

Passion _____

. . . in that moment I loved . . . so much I felt my insides split apart, pouring out this kind of light that made it hard to breathe, and what I couldn't understand was why it had to hurt so much and feel so sad to love someone that way.

David Payne (b. 1951)
American writer

. . . we are born to love
those who most wound us.

Lawrence Durrell (1912–1990)
English writer

*Passion*_____

You pierce my soul. I am half agony,
half hope. Tell me not that I am
too late, that such precious feelings
are gone forever. I offer myself
to you again with a heart even more
your own. . . . I have loved none
but you.

Jane Austen (1775–1817)
English writer

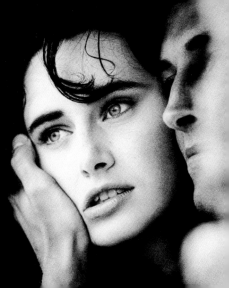

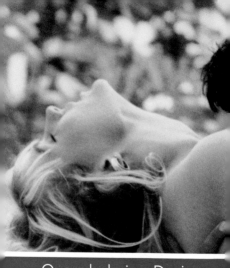

Overwhelming Desire

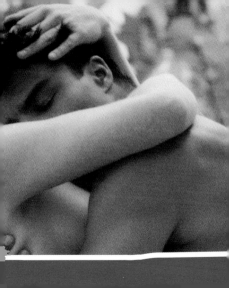

*Desire is an odd thing;
the closer one comes
to its attainment,
the stronger it grows.*

**Sandi Sonnenfield
American writer**

. . . love makes more love.
To love, to love anything
or anybody is to
start some kind of engine
that makes more.

Anne Rivers Siddons (b. 1936)
American writer

Passion _____

Why was this profound? . . .
Better than philosophy or medicine.
Why are we made to probe beneath
the skin so far?

Martin Cruz Smith (b. 1942)
American writer

I love you ever and ever
and without reserve.
The more I have known
you the more I have lov'd.

John Keats (1795–1821)
English poet

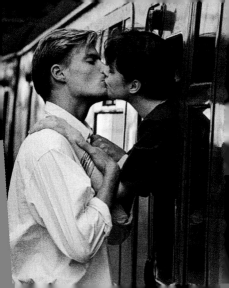

Passion

. . . Do not say, Which loved?
Which was beloved? Only,
 Who most enjoyed? . . .
Only find me and touch my
 blood again.
Find me.

Muriel Rukeyser (1913–1980)
American poet

There is no grief, no sorrow, no despair,
No languor, no dejection, no dismay,
No absence scarcely can there be,
 for those
Who love as we do.

William Wordsworth (1770–1850)
English poet

When they kissed,
it seemed to Annie she
was coming home.
That somehow she had
always known the taste
and the feel of him.

Nicholas Evans (b. 1950)
English writer

How I long to give
myself up in ecstasy
to your sweet breath
and to those kisses
from your lips which
fill me with delight!

Juliette Drouet (1806–1883)
French letter writer

Passion _____

All at once we both leap, like wolf mates reunited, searching for that which identifies us as belonging to each other: the scent of our skin, the taste of our tongues, the smoothness of our hair, . . . the slopes and creases we know so well yet feel so new. He is tender and I am wild, nuzzling and nipping, both of us tumbling until we lose all memory of who we were before this moment, because at this moment we are the same.

Amy Tan (b. 1952)
American writer

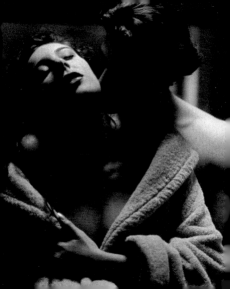

I have seen only you,
I have admired only you,
I desire only you.

**Napoleon Bonaparte (1769–1821)
French emperor**

When I see her, then I am well.
If she opens her eye,
 my body is young again;
If she speaks,
 then I am strong again . . .

Ancient Egyptian poem

Passion _____

*They held on to each other
as if love were an offering
they alone had discovered,
infinite in possibilities.*

Jo-Ann Mapson
American writer

. . . but my heart beats through my entire body and is conscious only of you. I belong to you; there is really no other way of expressing it, and that is not strong enough.

Franz Kafka (1883–1924)
Austrian writer

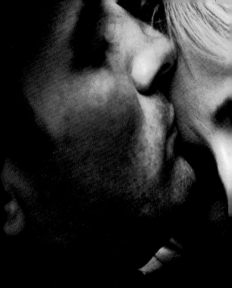

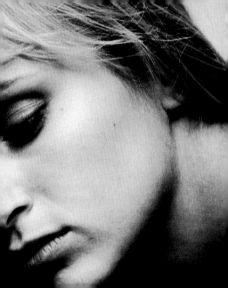

I have wept for joy to think that
you are mine, and often wonder
whether I deserve you. . . . What
would I not do for love of you!

Robert Schumann (1810–1856)
German composer

Nobody has ever measured,
even poets,
how much a heart can hold.

Zelda Fitzgerald (1900–1948)
American writer and adventurer

*Passion*_____

If you only knew how much
I love you, how essential you are
to my life, you would not dare
to stay away for an instant, you
would always remain by my side,
your heart pressed close to my
heart, your soul to my soul.

Juliette Drouet (1806–1883)
French letter writer

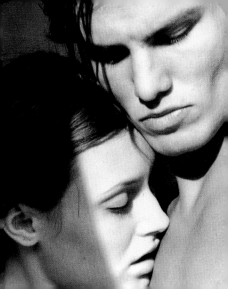

. . . life without passion
is nothing more
than a broken promise.

Barbara Raskin (b. 1935)
American writer

My love for you was never so strong as now, and I never was so little ashamed at any aspect of it; for I have now shown it to you in every light and you not only pardon my passion but love me the better for it.

Frank Lillie
American professor

We are minor
in everything
but our passions.

**Elizabeth Bowen (1899–1973)
Irish writer**

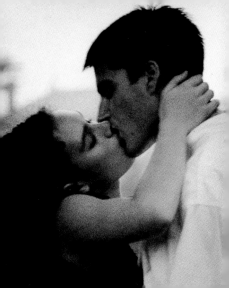

Everlasting Love

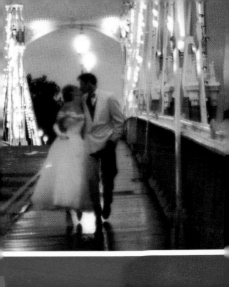

The pleasure of love
is to love, and one is happier
in the passion one feels than
in the passion one inspires.

La Rochefoucauld (1613–1680)
French writer

We were lost,
but in that lostness
I was not afraid
and not alone. That was
loving someone . . .

David Payne (b. 1951)
American writer

*Passion is what
you need to be good,
an unforgiving passion.*

David Easton (b. 1917)
Canadian educator

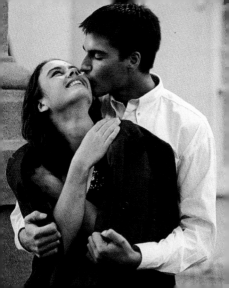

I am never away from you. Even now,
I shall not leave you. In another world,
I shall still be the one who loves you,
 loves you
Beyond measure, beyond—

Edmond Rostand (1868–1918)
French playwright

First prize is finding
someone to be
passionately in love
with you for a lifetime.

Judith Henry Wall (b. 1940)
American writer

In this world
love has no color—
yet how deeply
my body
is stained by yours.

Izumi Shikubu (974–1034)
Japanese poet

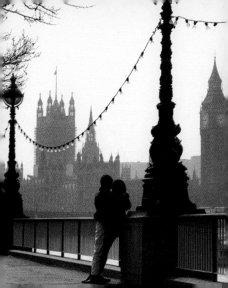

*Passion*_____

Two is a good number . . .

Carol Shields (b. 1935)
American writer

We fit each other. We don't have
to explain or argue. We make music
together. It isn't always like that
for everybody. We're the lucky ones.

Morris West (b. 1916)
Australian writer

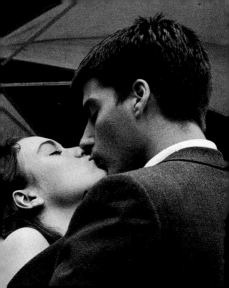

Are we not formed,
 as notes of music are,
For one another,
 though dissimilar?

**Percy Bysshe Shelley (1792–1822)
English poet**

I gave thee what could not be heard,
What had not been given before;
The beat of my heart I gave. . . .

Edith M. Thomas (1854–1925)
American poet

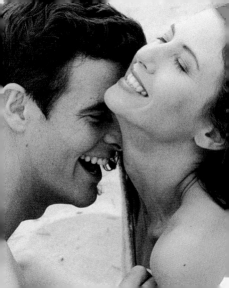

The little conversations
that break up our
thoughts, keep us sane
and make us feel loved.
I wish I could tell her
everything, take her into
my heart and mind.

Clifford Irving (b. 1942)
American writer

What is passion?
It is surely
the becoming of a person.

John Boorman (b. 1933)
English film director

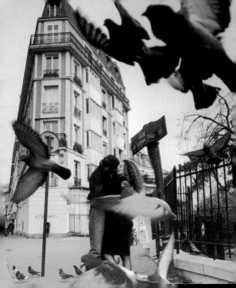

The more passions
and desires one has,
the more ways one has
of being happy.

Charlotte-Catherine
17th-century Princess of Monaco

. . . love needs no reciprocity,
it contains within itself both the
challenge . . . and the response;
it answers its own prayer.

Milan Kundera (b. 1929)
Czech writer and poet

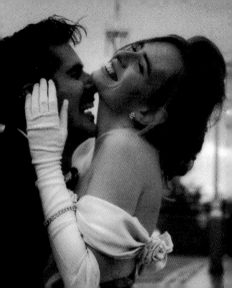

Love . . . may be your glimpse of transcendence.

Florida Scott-Maxwell (1883–1978)
English psychologist

This book has been bound using handcraft methods, and Smyth-sewn to ensure durability.

The dust jacket and interior were designed by Corinda Cook.

The text was edited by Elaine M. Bucher.

Photo research by Susan Oyama.

The text was set in Avenir and Shelley.

*sweet
romance*

*burning
hearts*

*wild
ecstasy*

*ignited
souls*